It's Your World

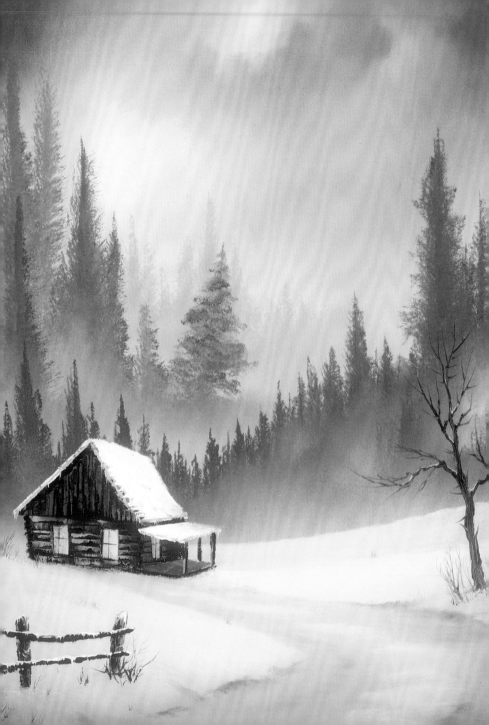

It's Your World

Creating Calm Spaces and Places
with

Bob Ross &
Robb Pearlman

UNIVERSE

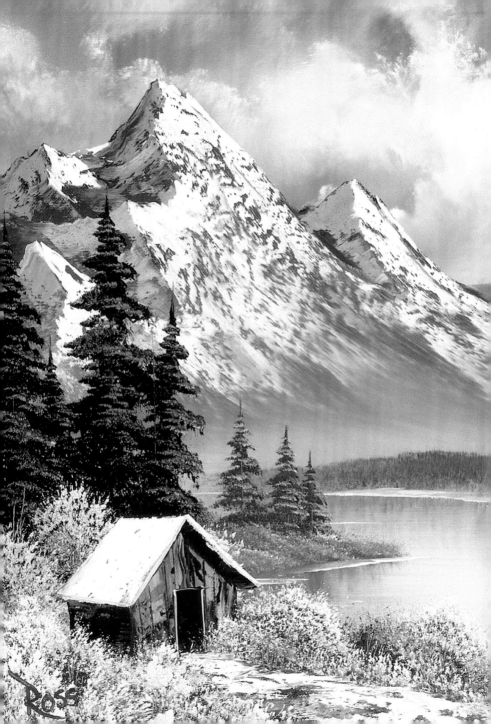

Contents

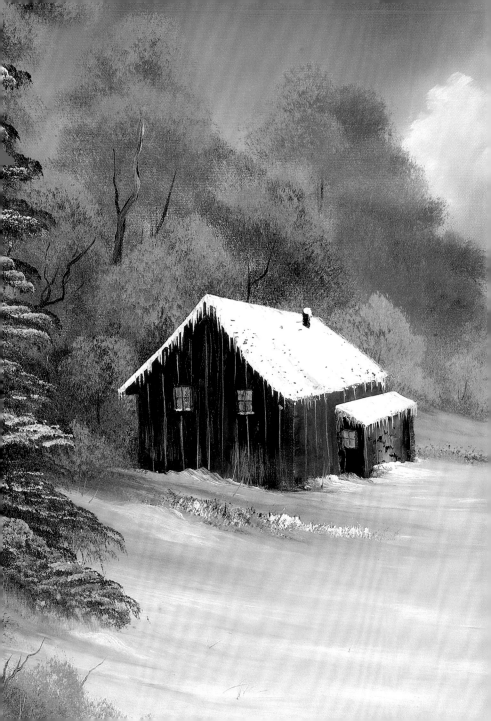

INTRODUCTION

Your Cabin in the Woods

"You have unlimited power here—you can do that. You can do anything on this canvas, anything..."

Untold thousands of people flocked to see and be taught to paint by Bob Ross during his in-person appearances and classes. Untold millions watched his iconic *Joy of Painting* series on TV in their family rooms, living rooms, and bedrooms. Thanks to the unique alchemy of his personality, talents, and the fact that television shows were beamed directly into our most personal spaces, Bob Ross achieved what few other teachers, painters, or television hosts could: he not only holds a special place in our hearts but has become a central part of our homes as well. His appearances on the television sets (and computers, tablets, and phones)

that serve as the literal and figurative focal points of our rooms give new meaning to the phrase "home is where the heart is."

Bob filled our homes with the sights and sounds of creativity, comfort, and beauty. He encouraged viewers of all ages and skill levels to use their imaginations to create cozy cabins in their own painted landscapes. So, it makes sense that the same lessons and wisdom he shared regarding painting can also be applied inside those self-made cabins—and to our living spaces.

Whether you live in a refurbished farmhouse on the prairie . . . or a white-picket-fenced house on a suburban lane . . . or an apartment in a glittering city, your home holds the power to showcase who you are and inspire you to live your best self.

> ### *There're enough unhappy things in the world. Painting should be one of those things that brighten your day.*

This happy little book will take you on a colorful tour through the creative journey of making spaces in your home that will bring you calm—and help you fill those spaces with peace and joy.

Each chapter will inspire you to apply Bob's techniques and methods so that you can draw on the painter within to shape comfortable, practical spaces; set priorities, face limits, and accommodate mistakes and compromises; and work with colors, textures, proportion, and balance. You'll even face some interactive bravery tests that will help you organize and plan, problem-solve, and challenge yourself to discover—and uncover—a host of newfound possibilities and options to make any space a *living* space.

Let's get started!

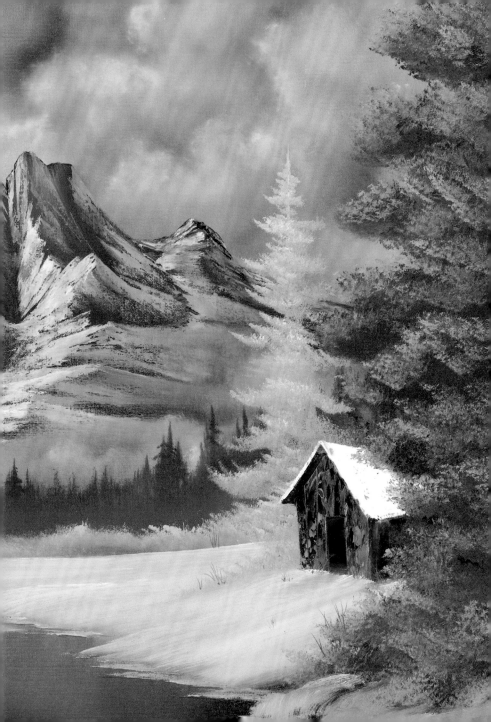

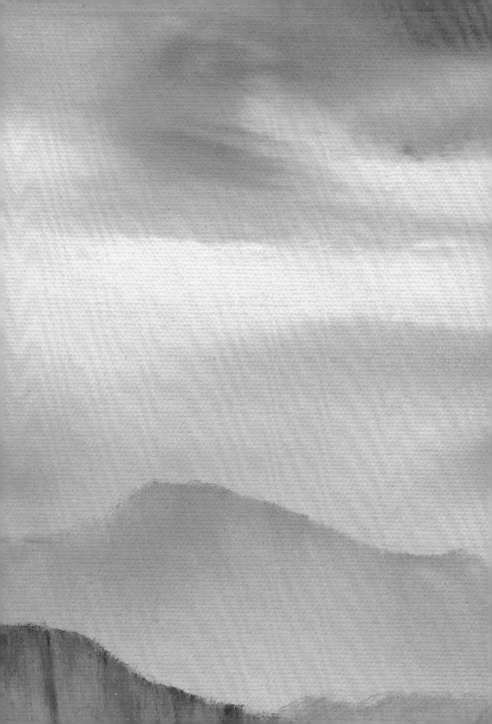

Equipment & Technique

Bob Ross engaged us by explaining his fundamental techniques and ideas.

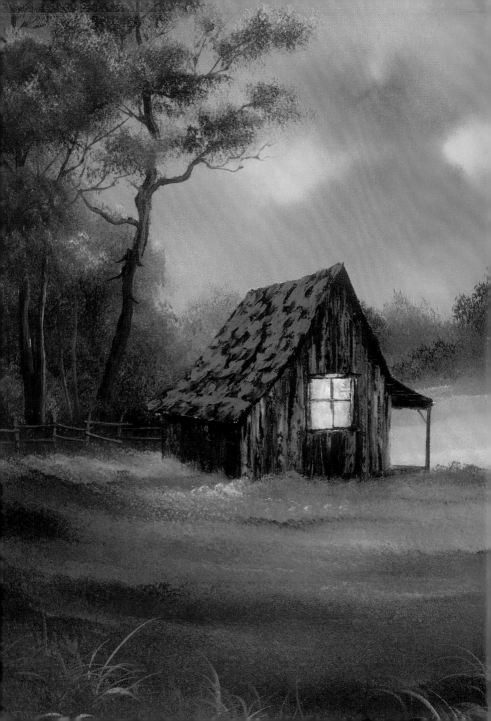

It's Your World

"This is your world right here, and there's no right or wrong. As long as it makes you happy and it doesn't hurt anybody else, then it's fantastic."

Bob Ross showed us, every week, how to live both within and without limits. Though constrained by the four edges of a blank canvas and a twenty-six-minute program runtime, Bob's limitless imagination created a legion of unique landscapes that reflected his interests, values, and worldview.

Every room can be seen as a blank canvas upon which to place your limitless imagination. And each room also comes with its own constraints that limit the spaces and world that you create.

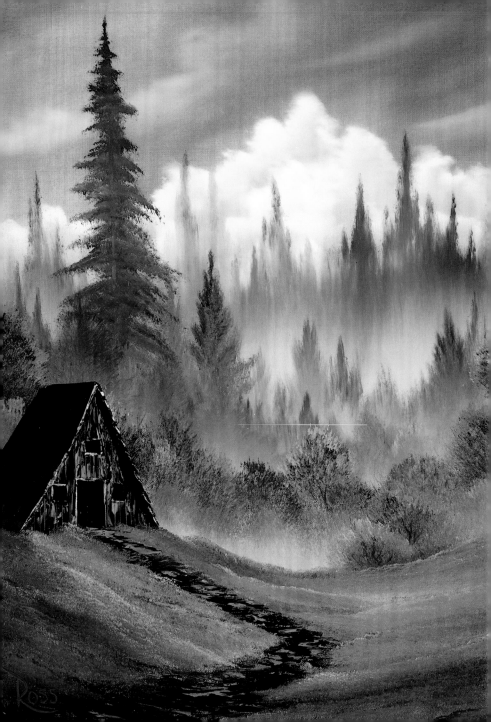

> *"All you need is a dream in your heart and the desire to put it on canvas."*

Your home is your world.

This is true whether you rent or own; whether your house is surrounded by rolling verdant hills or nestled among tree-shaded woods; whether your windows look out onto bustling city pavements or expansive crop-striped farms or you have a basement-eye-view of a cobblestoned-street in a historic town; whether your home overlooks sparkling sunny river views, windswept sandy shores, suburban lanes, interstate highways, or cul-de-sacs. We've all heard the phrase "location, location, location" as the driving force in real estate. The truth is that wherever you are, your home should welcome you and those you love.

As much as your home houses unlimited creative potential, it's important to recognize and appreciate the limits you're operating within. Creating meaningful, comfortable spaces begins by exploring what matters to you and the boundaries of your canvas. Are you a renter who must abide by your landlord's rules, or do you own your home (but still need to adhere to an HOA or board)? Do you live alone, or do you share common rooms or spaces? Are your rooms oddly shaped? Do you have to adapt or transform a space to your unique or personal needs? Are there things you need to work from home?

BRAVERY TEST

"Let's get crazy, what the heck!"

Just for fun, use this page to list the spaces you'd work on if you had no limitations.

..

..

..

..

..

..

..

..

..

..

..

..

..

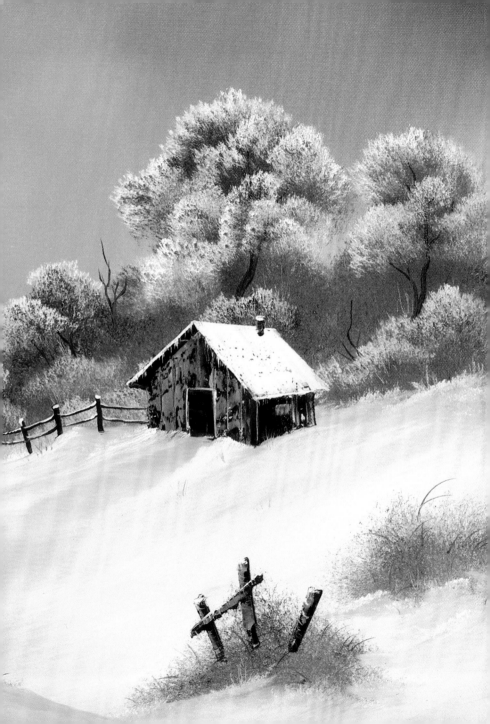

BRAVERY TEST

"Let your imagination be your guide. There are absolutely no limits here."

Now that we've stretched our imaginations, let's get back to the blank canvas we have. Use this page to list the rooms you'd like to redesign or reimagine. For each of them, list their limitations.

..

..

..

..

..

..

..

..

..

..

..

..

..

..

Now use this page to list creative ways to work within those limitations.

..

..

..

..

..

..

..

..

..

..

..

..

..

..

..

..

..

..

..

..

..

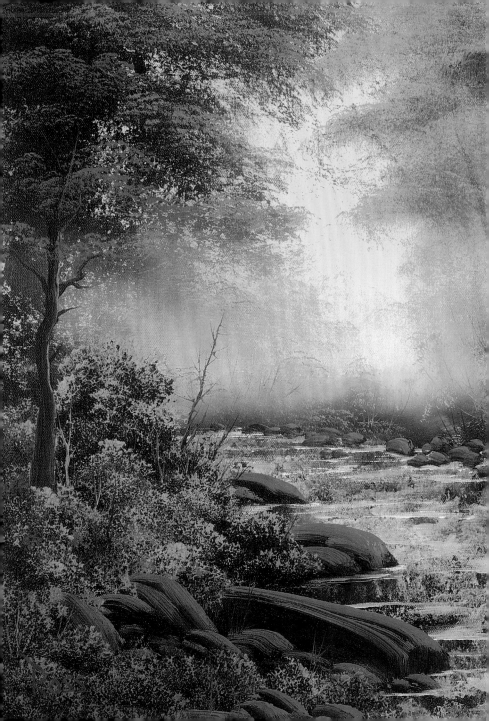

Let's Paint a Happy Picture

"By allowing these colors to blend on the brush, you get a multitude of different values and colors rather than just one old flat color. Put some excitement in your world."

Thanks to the wonders of nature and modern technology (and influencers touting the latest trend), we live in a world of infinite colors and infinite color combinations. But Bob didn't need anything other than the thirteen colors he used every week to create every single one of his landscapes. Darker greens and browns would evoke the dense lush forests of summer, while a combination of white and blue added a chill to any winterscape.

Though Bob's demeanor was always calm and welcoming, his paintings offered a wide variety of moods.

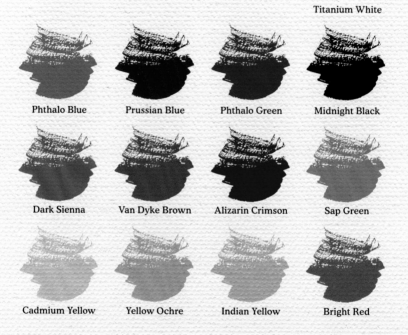

Titanium White

Phthalo Blue Prussian Blue Phthalo Green Midnight Black

Dark Sienna Van Dyke Brown Alizarin Crimson Sap Green

Cadmium Yellow Yellow Ochre Indian Yellow Bright Red

Whether the loneliness of a solitary cabin in the woods or the togetherness of myriad wildlife hidden within the trees, bushes, and rushing waters of an overgrown forest, each of Bob's paintings makes you feel something. Color can have a clear and direct effect on your mood. Colors calm, energize, or even inspire. Whether bashful or bold, soft or loud, muted or vibrant, the colors we surround ourselves with—especially the hues of the paint on the walls and the items of decor in our personal spaces—can reflect, radiate, and amplify our emotions and intentions.

BRAVERY TEST

*"And at home you can do these in any color
that you like."*

Use this page to record the colors you feel a connection to, and how
they make you feel. You can paste in swatches; use paint, crayons,
or markers; or simply list the colors.

Different color combinations can feel more naturally complementary or conflicting or evoke a particular mood, setting, or experience.

For example, Bob's standard uniform of blue shirt and blue jeans always made us feel welcome. Some color combinations have become particularly popular in interior design and decor. Use the following as shortcuts to color combinations that have become associated with a particular look:

LOOK	COLORS
Clean	Whites, grays
Classic	Blues, reds, yellows
Cool	Deep blues, greens
Hot	Vivid reds, oranges
Fresh	Yellows, lime green, light orange
Woodsy	Browns, forest green, brassy gold
Nautical	Yellows, navy blue, crimson
Americana	Indigo, barn red, cream white, oaken brown
Tuscany & Provence	Olive green, butter yellow, blue-lavender
Urban	Silver, blue-grays, charcoal
Soft	Pinks, lavender, peach
Beachy	Turquoise, seafoam, light peach, ochres, aquamarines
Modern	White, black, grays
Muted or neutrals	White, tan, light ochre, grays
Antique	Wood stains, nickel, bronze, brass, coal
Christmas	Red, green, white, silver, gold
Rainbow	Red, orange, yellow, green, blue, indigo, violet

BRAVERY TEST

Use these pages to list the color combinations you think will help
you feel the way you want to feel in each of your living spaces.

..

..

..

..

..

..

..

..

..

..

..

..

..

..

"It took me thirty years and twenty-six-minutes to paint this painting."

Bob understood that creativity and choices need to be informed and guided before they can be put into motion.

So you may need more than practical tools like paint, paint brushes, and decor to create your spaces. Bob would be the first to admit that his paintings were influenced and inspired by his appreciation of the world he lived in—as well as those who came before him. There would have never been *The Joy of Painting* had Bill Alexander not paved the way with his own *The Magic of Oil Painting* program. And neither Bill's nor Bob's famed wet-on-wet painting techniques would have existed had it not been for old masters like Vincent van Gogh.

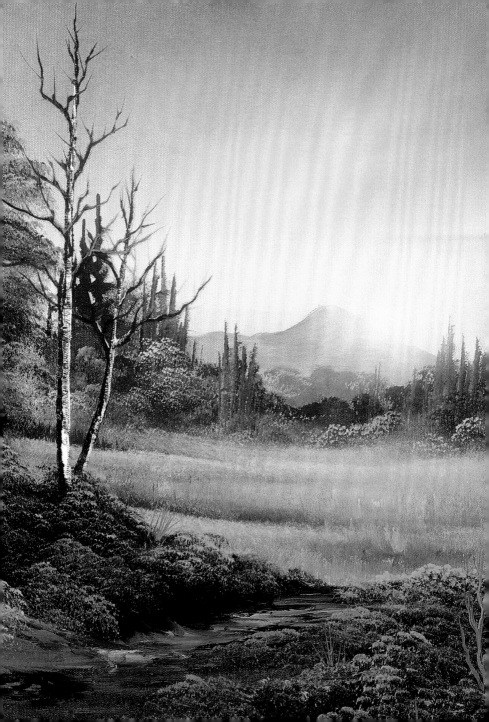

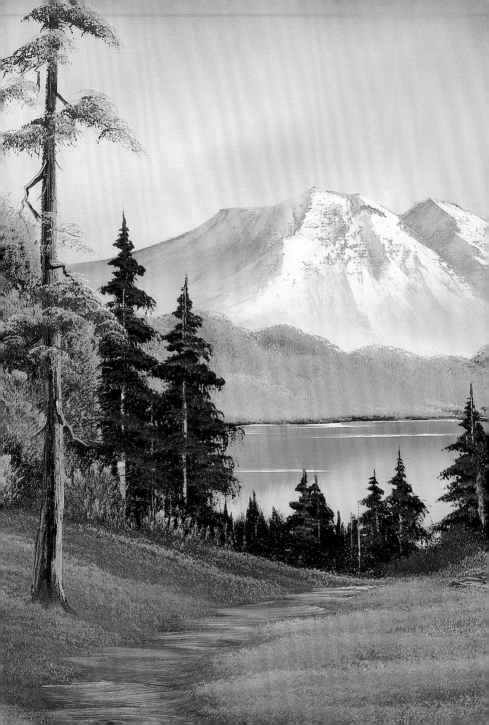

"I don't try to understand everything in nature. I just look at it and enjoy it."

Bob famously spent hours walking in nature, studying its colors and sounds and the interplay of natural elements.

To follow in Bob's literal and figurative footsteps, nothing beats a good walk or hike in pure, unspoiled nature. But not all of us are lucky enough to have easy access to such places. Instead, you can try sitting in a park or on the beach, or even in a yard or garden.

For even more inspiration, try visiting a local museum, art gallery, studio, library, craft fair, or farmers market. Look for hidden spaces that feature paintings, sculpture, or artwork. Bookstores, especially independent or specialty ones, can provide tons of books and resources for you to browse through (and buy)! And feel free to take advantage of visiting home shows, open houses, or model apartment viewings to see colors, design elements, and decor as they work together (or not!) in other similar living spaces.

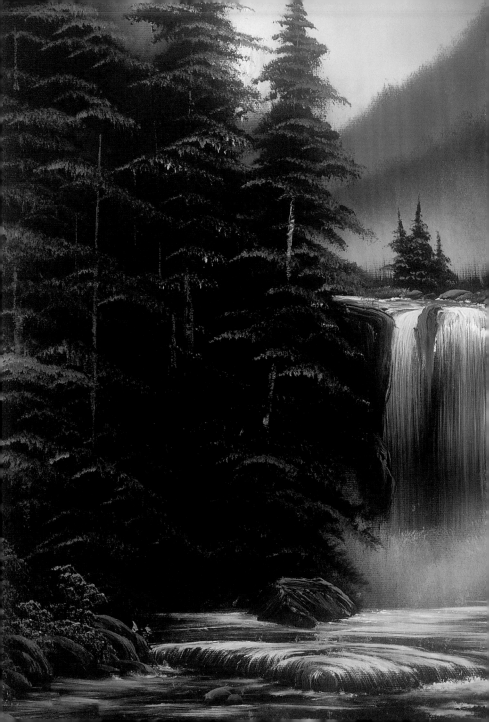

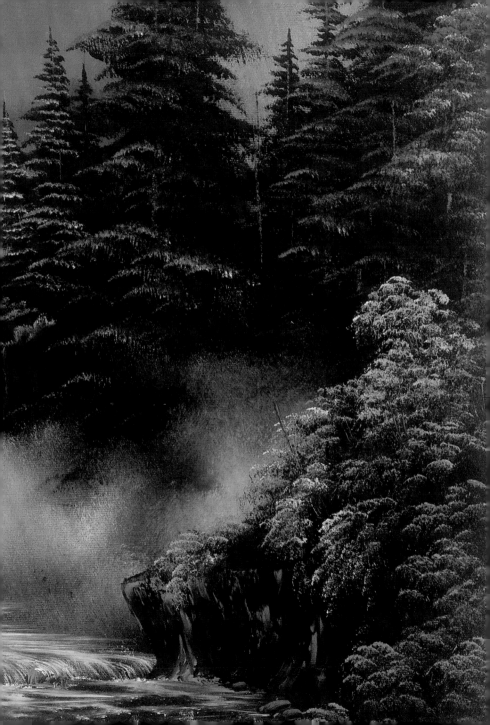

BRAVERY TEST

"Years ago, Bill taught me this fantastic technique, and I feel as though he gave me a precious gift, and I'd like to share that gift with you."

Use these pages to list or paste in pictures of the things that inspire you.

..

..

..

..

..

..

..

..

..

..

..

..

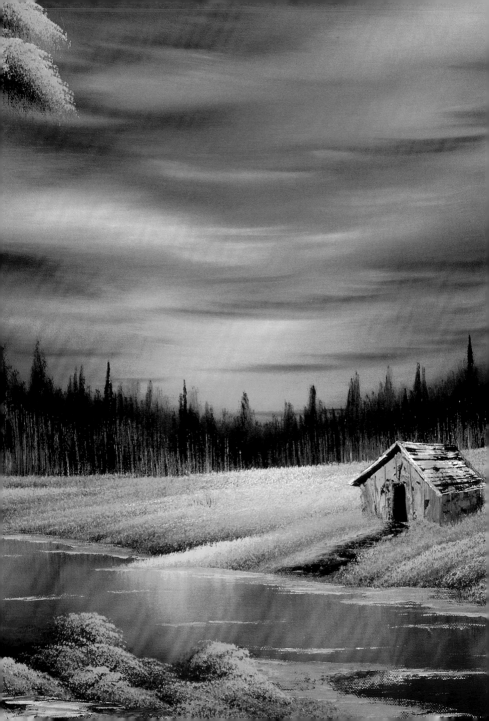

The Basics

"The more you paint, the more you're able to visualize...you really can learn to be creative as you paint. It's like anything else—it just takes a little practice."

Behind Bob's improvisational approach was a lifetime of rigorous observation and a deep understanding of the artistic principles of composing with shapes, color, and texture. These tried-and-true rules can also be employed for decorating and organizing a space.

> *"When you paint, you begin to see things. Let 'em happen...*
> *Learn to compose as you paint."*

Bob made trees, mountains, and clouds look as if they naturally existed,

along with cabins and fences in an ecosystem defined by the human-engineered straight lines of a canvas. Bob also sometimes played around with the idea of shapes by framing his paintings in other shapes. Circles, squares, ovals, rectangles, triangles, and hexagons are fundamental geometrical elements that can work with the freeform organic lines we see and experience in nature.

When you're choosing furniture such as couches, tables, chairs, headboards or bookcases, or decor such as pillows, picture frames or mirrors, rugs, artwork, or even bookcases and storage chests, think about their shapes and how they'll work together. Do you prefer the more uniform look of all straight edges? Do you like more curvilinear lines? Do you have a connection to a particular design element such as a fleur-de-lis or sunburst? Or do you prefer an eclectic mix of everything?

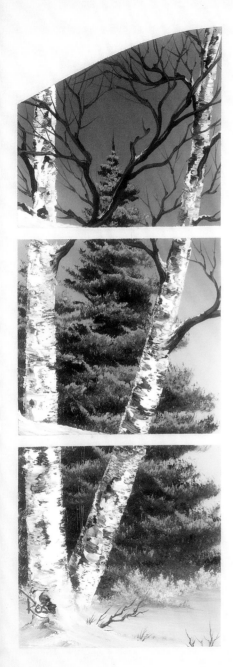

BRAVERY TEST

"Now we're going to put some basic tree shapes in there."

Use this page to sketch or paste in shapes that you'd like to incorporate into any of your spaces.

Once Bob had decided the season or time of year in which he would be setting his painting, he already had a good idea of the colors he'd want to use.

A tree with bright red leaves would make perfect sense in an autumnal landscape but really stand out in an odd way in a winterscape. Once you've determined the overall color palette of a room, you can strategize how those colors are going to work together. Do you want them to complement one another or to blend? Or would you rather have contrast, so that one color pops against another?

Most of Bob's daytime paintings featured clouds and direct or indirect sunlight. Because your eye was drawn upward toward his happy little clouds, clear blue sky, and snow-peaked mountaintops, the uppermost portions of his paintings had a feeling of airy weightlessness that balanced out the earthbound trees, brush, and creeks. You could feel the grass under your feet as much as you could the easy breeze through your hair. If you prefer a subtle or monochromatic look, paint all the walls one color, and the ceiling a lighter or more neutral color. (Painting the ceiling the same color as the walls, especially in a small space, might make the room feel a little closed in.) This will give the room a sense of height that draws the eye upward. Unless you're going for an all-white room or a room that is, in general, painted a lighter color, it's usually best to pick a lighter color for the ceiling.

Bob was no stranger to excitement, though, and in a painting filled with white snow, he'd often include a colorful hue in the sky to grab viewers' interest. If you'd also rather go for a little drama or excitement, paint one wall a brighter or drastically different color than the others. You can even forgo the paint altogether and choose to wallpaper that one wall. This wall will serve as a statement or focal point of the room.

"Allow the colors and the paint—everything—to work together to make it easy."

BRAVERY TEST

"People use too much pressure. Use absolutely no pressure."

Use this page to sketch out the general shape or dimensions of your rooms, and the colors, wallpaper, or patterns you're considering for each of the surfaces.

"One thing about mountains when you're painting them—they should always be more distinct at the top than they are at the bottom. At the bottom of the mountain we have mist (and now pollution). All these things diffuse and break up light at the bottom of the mountain."

Bob would always paint the background first and then move toward the foreground,

but no part of a Bob Ross landscape was less important than another. Accent rugs, wood flooring, or wall-to-wall carpeting that complement the walls and ceiling will help draw all the space's elements together and complete a cohesive look. Darker floors may be easier to maintain than lighter floors, but whatever flooring materials you choose will work as long as they figuratively ground the space they're literally grounding!

And though Bob painted lush, verdant forests, you could always see at least some individual trees. To that point, try using a variety of textures in the same color or color family to add visual interest and create definition between all the individual elements. For example, try laying a tan deep-pile rug on a tan floor, or set gray silk pillows on a gray leather couch that's placed against a gray matte wall. Though the colors are all the same (or nearly the same), the differences in textures will give them a diverse yet unifying look and feel.

"You know what happens if there are two trees. Pretty soon there are going to be three and then there are going to be four, and then you're going to have a forest."

Bob always seemed sad whenever he noted only one tree or one mountain in his painting.

Everyone needs a friend! When it comes to decor, many interior designers go by the "rule of threes." An odd number of items placed together feels more organic (or less intentional) than an even number of items. So set three candles or framed pictures on a mantel. Hang three pieces of art on a wall. Place three flowerpots on the windowsill.

And when Bob was painting a mountain range, hedgerow, or line of trees, he remembered another important rule: in nature, nothing is perfect, and everything grows and evolves in its own time. So if you're placing three similar things together, break up the visual line by using a variety of heights to give it more interest.

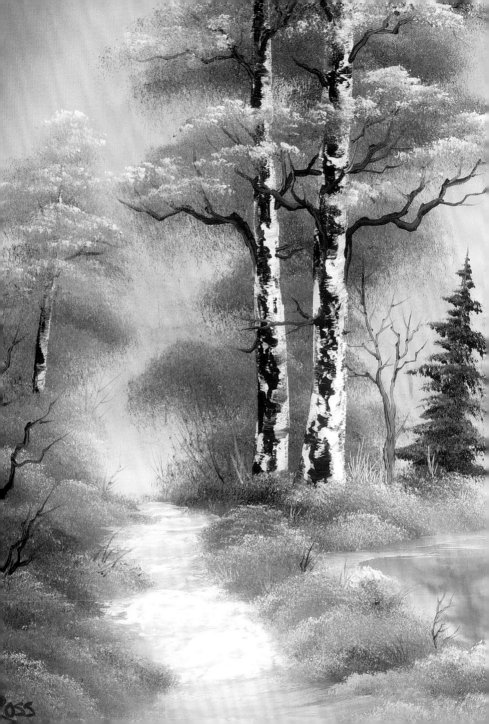

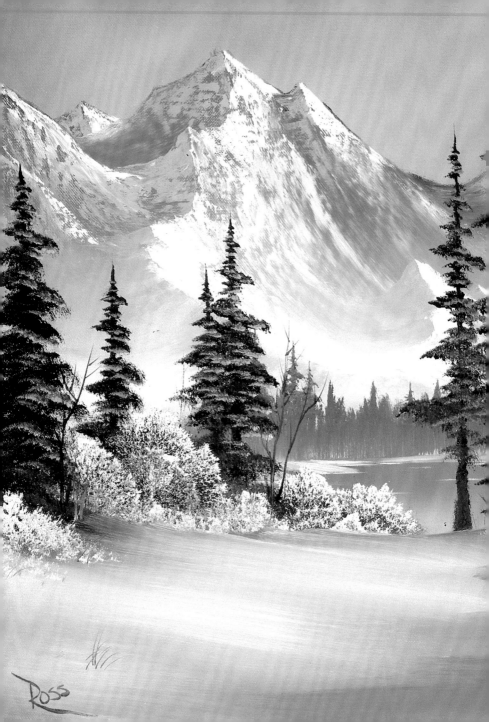

"It only takes a second to sign a painting."

At the end of Bob's show, he'd always use a liner brush to sign his painting.

This was more than an artist's vanity. Signing a painting was Bob's way of showing—to himself and the viewer—that he had indeed put himself into this work.

The most beautiful rooms and spaces can feel hollow and empty if they contain nothing personal or meaningful. Hotel rooms, theaters, or restaurants can be beautiful, but they're all designed to appeal to as many people as possible. It's only when a space is designed by and for someone specific that you can truly feel comfortable and at home. Don't be afraid to include things that are important to you in your space. A family heirloom has just as much decorative value as a collectible plate or even your own Bob Ross–inspired painting, so if you feel a deep and meaningful connection to it, if it signals to others—and you—that the space is yours, then use it! Remember, this is your world! So rather than adhering to a set of rules made up by someone else, do whatever makes you happy!

BRAVERY TEST

"You may have noticed by now that we use no patterns and we do no sketching. We let this flow right out of our heart onto the canvas."

Use this page to list the decorative items you'd like to use.

...

...

...

...

...

...

...

...

...

...

...

...

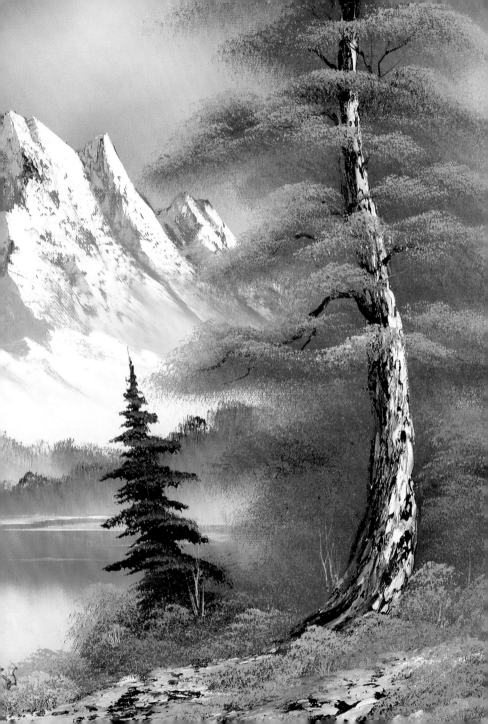

Opposites

"Gotta have opposites—light and dark and dark and light—in painting. It's like in life."

With a little planning, and a few well-placed brushstrokes of light or dark paint, Bob was able to add moonlit highlights to a night scene or shadows into a sunny daytime vista. When you play with contrasts, as he did in his paintings, you can learn how different colors, shades, and textures work with one another.

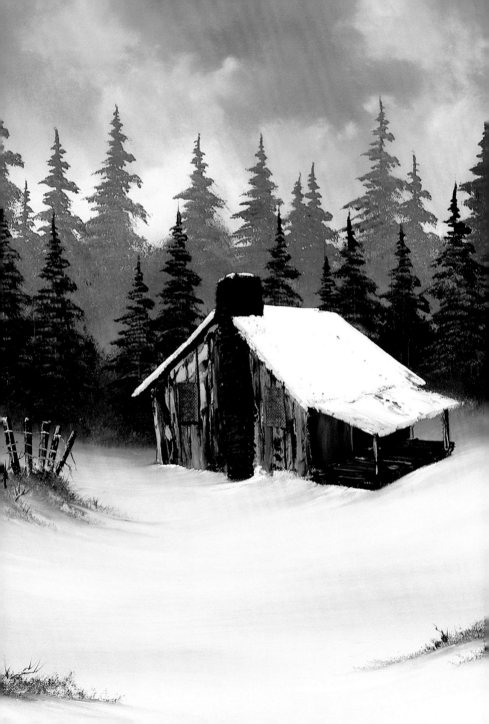

"Let's put a few little highlights in here to make them little rascals just sparkle in the sun..."

Bob understood that a painting, however beautiful, could look very different in different settings.

When he painted under the bright lights in his studio, the colors that he saw on his palette were somewhat different than the hues viewers saw on their home television sets (especially before the invention of high-def!). And those paintings looked a little different to him in the studio than they did hung in his office. The appearance of our rooms is also ever changing, affected by the time of day or night, the season and the angle of the sun, the weather, and even the voltage and hue of lightbulbs.

Take a look at the functionality of your spaces at different times of the day. Do you need directed or work lighting to see better in dark or hard-to-see areas or corners? Does the room face south or north and need more overhead lighting? Do the windows look to the east and require blackout shades in the morning? Is the sun streaming in through the westerly windows and reflecting on your television or computer screen?

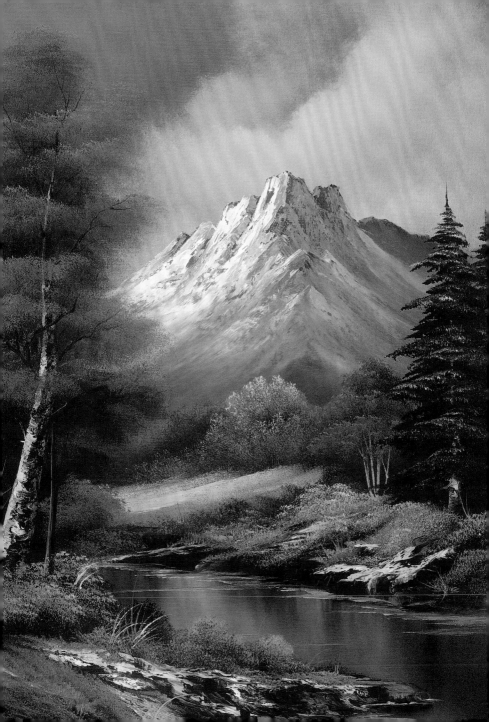

BRAVERY TEST

Use this page to list the directions your spaces face, what times of day they get the best natural light, what kinds of lighting they have, and what kinds of lighting you need.

Space: ...

Orientation: ...

Natural Light:...

Lighting It Has: ...

Lighting I Need: ...

Space: ...

Orientation: ...

Natural Light:...

Lighting It Has: ...

Lighting I Need: ...

Space: ...

Orientation: ...

Natural Light:...

Lighting It Has: ...

Lighting I Need: ...

Space: ..

Orientation: ...

Natural Light: ...

Lighting It Has: ...

Lighting I Need: ...

Space: ..

Orientation: ...

Natural Light: ...

Lighting It Has: ...

Lighting I Need: ...

Space: ..

Orientation: ...

Natural Light: ...

Lighting It Has: ...

Lighting I Need: ...

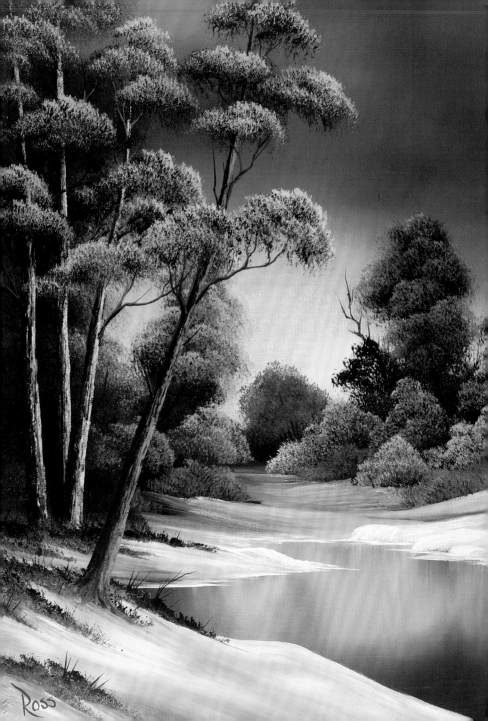

"Anything we don't like, we'll turn it into a happy little tree or something, because as you know, we don't make mistakes, we just have happy accidents."

As skilled a painter as Bob was,

an errant brushstroke might turn a mountaintop into a cloud, or transform a tall, strong tree into a fallen, broken log. Similarly, few design or decorating projects will stick perfectly to plan. Most people have bought a piece of furniture that was too big—or too small—for a space. Rooms that seem to have perfectly straight walls wind up with corners that are not close to 90 degrees. Floors that should be even instead send a desk chair rolling across a room. And though we can mitigate the chances of choosing a wrong paint color, lots of people realize the green they've chosen is too green, or the white is too white sometimes days (or even minutes) after painting an entire room . . . or house!

It's key to remember that the process of designing your space should be fun. So rather than becoming frustrated, angry, or even disappointed—especially about the things that don't turn out exactly right—try to appreciate it as part of the entire experience.

Bob understood how important it was to practice and try things out.

The years he spent building his skills and refining his teaching techniques prepared him to host *The Joy of Painting*, but he appreciated the need to prep for each individual episode. To make sure he didn't waste any of the twenty-six minutes of airtime, he'd often try out different compositions or themes on practice paintings before filming, and he prepped each canvas with a layer of Liquid White before proceeding to the landscape. The preparation, practice, and trial-and-error invested before every episode allowed viewers to enjoy a seamless experience.

It's true that a little preparation can help you avoid mistakes. (And most purchases can be returned with few or no problems—just keep the receipt!) Before you spend a lot of money on gallons of paint, spend a few dollars on a sample and a few days living with the color. Measure the dimensions of your room carefully. Ensure your walls really do meet at right angles by placing a book (or another object with edges at 90 degrees) in each corner. Tape pieces of paper together to approximate the length and width of each piece of furniture, and place them on the floor in the space to make sure they fit. You'll not only be able to physically experience how big or small the pieces are but also check that their placement allows for doors to open fully, and that you have enough space to walk around.

When you're painting, make sure to use a good painter's tape to protect windowsills, baseboards, door jambs, or anything else you want to keep paint-free. Drips and drops are going to happen, so start with the ceiling, and then the walls. Lastly, if it's part of your plan, refloor with hard wood, laminate, carpets, or rugs.

"If painting does nothing else, it should make you happy."

"Maybe down here the water hits and you can see it coming out of the mist, and maybe there are some stones down here. That's all right. If you want a stone, take a little brown, put a little stone in there, or two, or ten, it's up to you. Put as many or as few stones as you want in your waterfall."

Bob was extraordinarily intentional in the way he composed his landscapes.

He never put more clouds in the sky than the weather warranted. His wintertime branches never had too many leaves. The fences surrounding his cabins always had the required number of fenceposts to keep them from completely falling over (and not enough to keep them entirely upright). And though the water may have been lazy, it was never dammed up by too many rocks. Bob understood that a painting with too much to look at would quickly become a painting in which nothing could be found. Some rooms require many things in them to be functional and practical, but do think about how much "stuff" you really need in your spaces.

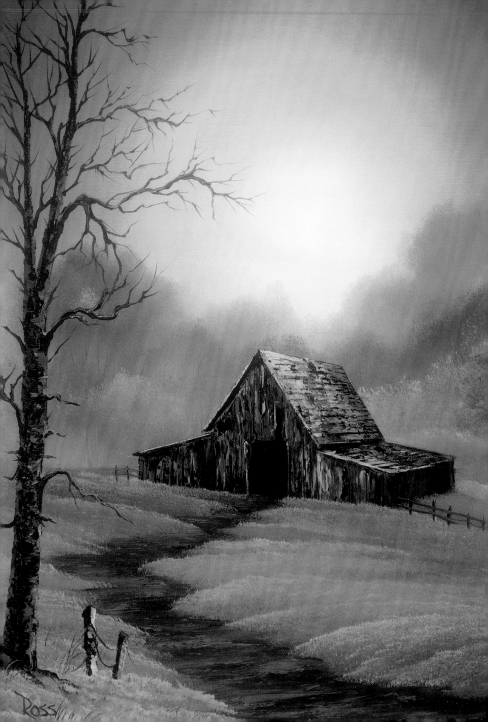

"Now we shake the brush into a box, and then beat the bristles dry."

Certain people thrive while surrounded by piles of paper on their desks or love to see their walls covered with photos.

But even if you know exactly where the holiday lights are buried in the garage, an amount of decluttering and organization can go a long way toward providing a sense of calm and comfort—especially for anyone visiting or sharing the space with you. There's nothing wrong with thriving amongst your things, but if you're starting to feel over-whelmed, disorganized, or just uncomfortable in your space, you might want to consider decluttering, organizing, and exploring storage solutions.

Whether it's dark and light, day and night, life is all about finding balance. It's up to you to determine and acknowledge just how much stuff you have, how much you want or need, and how much you can do without.

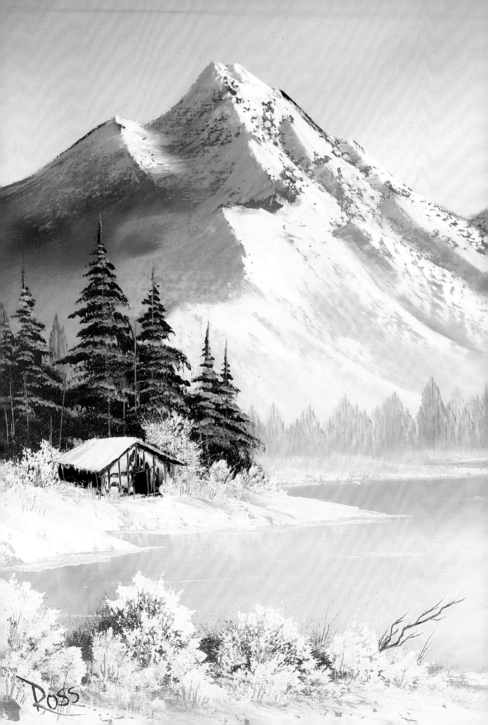

BRAVERY TEST

―――――

"Now, if you do this at home, it's a quick way to redecorate your living room in a second, so be careful. Learn how to contain this."

In your spaces, what things must always be in your sight or at the ready?

...

...

...

...

...

...

...

What things can be organized?

...

...

...

...

What things can be donated, recycled, or thrown away?

..

..

..

..

..

..

..

..

What things can be stored for use at another time?

..

..

..

..

..

..

..

..

Of those items, what will be used within a year?

..

..

..

..

..

Of those items, what will not be used within a year?

..

..

..

..

..

Of those items, what can be donated, recycled, or thrown away?

..

..

..

..

All Kinds of Details

Bob Ross taught us how to apply his techniques to specific elements in his paintings.

Friendship

"And that may be the true joy of painting, when you share it with other people. I really believe that's the true joy..."

Bob Ross represented sharing his love of nature by placing cabins and other spaces to live or meet within his landscapes. Bob could be described as a visual poet in the tradition of naturalist Henry David Thoreau, whose own famed modest cabin on Walden Pond housed a vacant chair as a standing invitation for a guest. Bob recognized that anything, especially painting, is best when shared. Not only would he sometimes welcome a guest to join him on *The Joy of Painting*, but Bob was also supported, throughout the series—and in life— by a legion of people working behind the scenes. Camera operators, producers, technicians, and lots of other professionals shared the studio with Bob. To say nothing of everyone watching who shared in the experience!

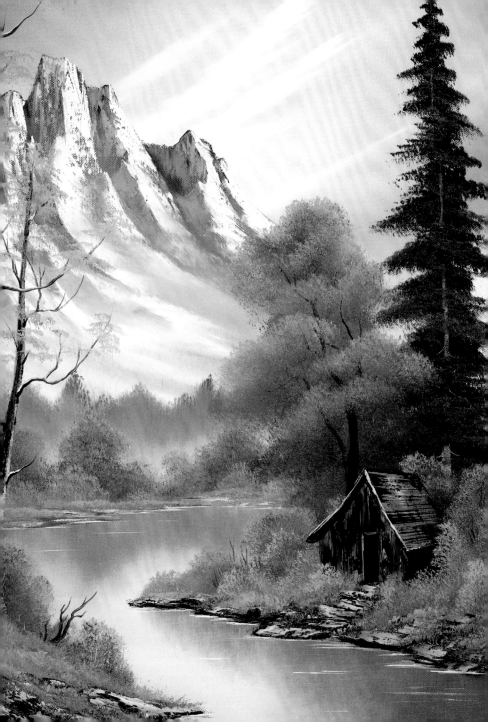

When Bob was painting a barn or cabin on his canvas, or even a pathway carved through the woods, he thought about how and why they were being used. Many homes feature an open floor plan in which kitchens, living rooms, family rooms, and offices occupy one giant room—but unless you live alone, your home is going to have some spaces that are designed for gatherings. A formal living room or casual family room, a dining room table or kitchen island, an entryway or mudroom—how and where we choose to congregate with friends and family plays a significant role in how spaces are designed and, more importantly, used.

"I think everybody needs a friend."

When thinking about a communal space, first consider how many people it needs to accommodate.

Bob's cabins were painted to look as if they were not only part of the environment but made of the elements found within the environment as well. Nonetheless, you may want your communal space or spaces to really stand out, like an evergreen amongst the barren trees of winter.

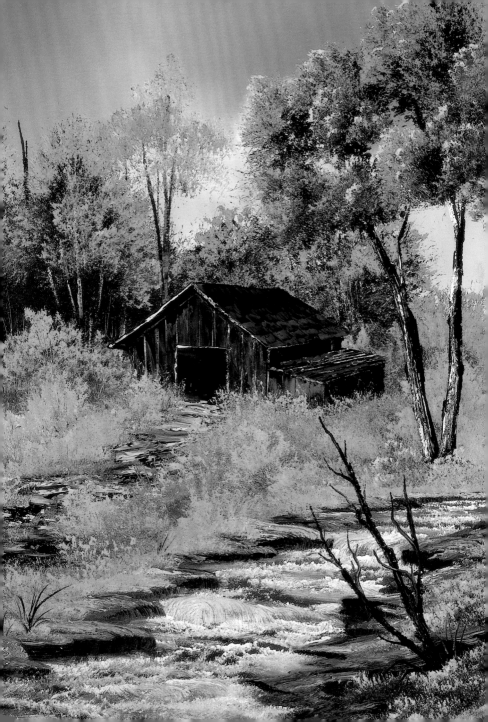

BRAVERY TEST

Use this page to list the areas in your home that are meant to be shared by others, how they're currently being used, and how you'd like them to be used.

..

..

..

..

..

..

..

..

..

..

..

..

..

..

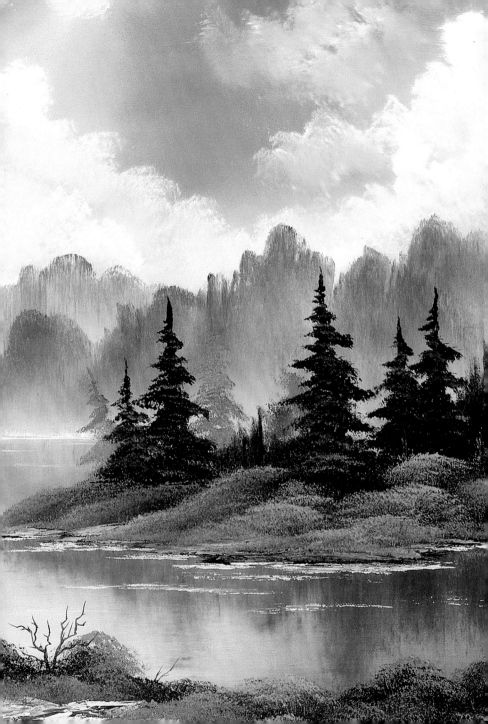

Form often follows function.

For example, when Bob painted a fence, he made sure to include enough fenceposts to make it look like a functional element, in addition to defining the cabin's boundaries. And, if a fencepost was missing, he made sure to show that the fence was falling down! Ask yourself: Are these areas meant to be formal or casual? Are they going to be used every day or only on special occasions? Do they serve a dual-or-more purpose, such as a living room that needs to convert to a guest room, or a dining room that's also used as a study or homework space and laundry-folding room?

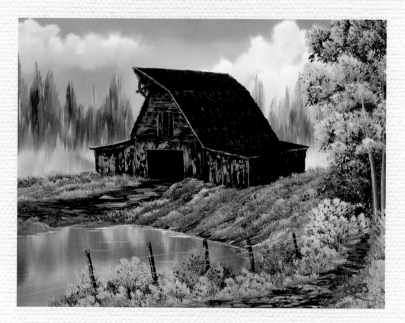

"We call those happy accidents and they can be your best friend."

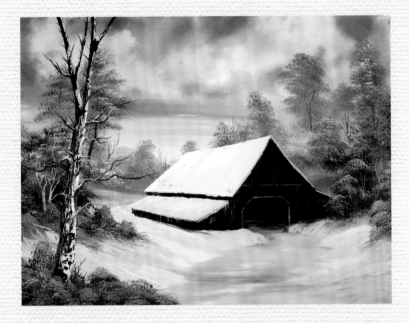

Bob famously said how important making mistakes was in the creative process.

It's true that you need to live in a space for a little while to determine if it's working for you (or not). Learn to celebrate the "happy accidents" that you didn't plan, and if something isn't working, to change it up! Remember you're the one determining what your world is like!

BRAVERY TEST

"You make all the decisions."

Use this page to list your communal spaces and the pieces of furniture, seating, or storage you need to make each space functional.

..

..

..

..

..

..

..

..

..

..

..

..

..

..

Creativity

"You can create all kinds of beautiful effects, just that easy..."

Bob often painted in his art and television studios, and he also painted in classrooms, convention centers, malls, and other public spaces throughout the years—as did his in-person students. However, millions of *The Joy of Painting* viewers painted their own pieces of art in their own living rooms, kitchens, dens, and even bedrooms—proving, time and again, that creativity is not found in any specific space. Instead, it comes from within. People find unique ways to be creative, and to their own tastes. Someone cooking in a kitchen is just as creative as someone knitting in a living room or painting in a studio or crafting in a basement or even building in a garage. The key to creativity is to recognize it within yourself, and give yourself the mental and physical space to let it shine!

"You actually blend the painting on the canvas."

Bob believed that food, water, shelter, and even little squirrel friends to keep you company could all be found in nature—

if you cared for the natural environment and took the time to look. Since kitchens often serve multiple purposes—food preparation and serving, social gathering, informational hub—the best kitchens blend form and function.

BRAVERY TEST

"Don't be afraid to go out on a limb, because that's where the fruit is."

Use the space below to sketch the layout of your current kitchen. Be sure to include furniture; major appliances; and any storage, prep spaces, shelving, and even wheeled islands or carts. Note where you feel most creative and efficient. Then note where you want to make improvements to be even more creative and efficient!

BRAVERY TEST

Use this space to list all of the small or portable appliances, like blenders, mixers, and air fryers you have in your kitchen.

..

..

..

..

Now list all of the small appliances that you actually use on a regular basis.

..

..

..

..

What small appliances that you don't use could you donate or recycle?

..

..

..

..

"In life, you need colors."

Bob's use of color, especially in his summer and spring scenes,

made every landscape look (and feel) as if it could provide a beautiful bounty to anyone who walked through them. However, unlike a casserole or plate of ratatouille that presents a wide variety of colors and flavors on a plate, kitchens can't really use all of the colors on a palette on its walls; they tend to work better if painted in more appetizing or neutral tones than, say, off yellow or neon purple. Kitchens are great spaces to use color trios, as you can think about different colors for cabinets, backsplashes, and flooring. Kitchens also give you the opportunity to use fun accent colors for small or large appliances to pop against countertops.

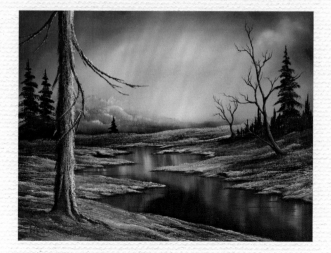

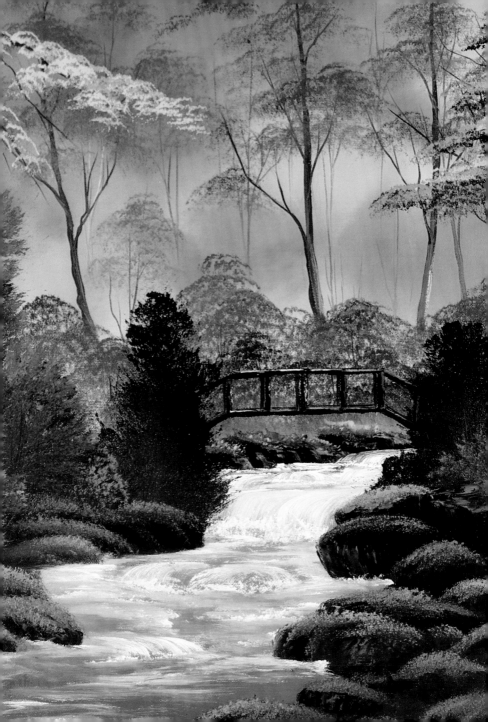

BRAVERY TEST

"I think it's time we had some fun now."

Use this space to list, paste in swatches or pictures, or color in the colors you'd like for your kitchen.

> **"If what you're doing doesn't make you happy, you're doing the wrong things."**

Before Bob focused his creative passions into painting, he grew up learning the craft of carpentry from his father.

However, as an active duty servicemember in the US Air Force, Bob probably didn't get to enjoy a dedicated space for painting. Once discharged and in his own home, he was fortunate to have many places where he could pursue his artistic endeavors. With a little planning, many spaces can be transformed into places of creativity.

Bob's art studio had to be big enough to hold cameras, lights, and the many people who helped run his TV show. Bob himself and his easel didn't take up all that much space. How much space do you need to be creative? Can you be creative sitting on your couch with your laptop on your lap, or do you need a small table in the middle of your living room. Or do you need an even larger space, such as a corner of a basement or an entire garage?

BRAVERY TEST

*"Anything that you believe
you can do, you can do."*

Use this space to list all of your creative pursuits (or those of the
people you live with), and the materials or tools you need to be cre-
ative. Note which ones need to be out and at the ready and which
can be stored.

...

...

...

...

...

...

...

...

...

...

...

...

Now list the ways that these materials or tools are currently organized and stored. Note which ones need to be better organized and stored.

..

..

..

..

..

..

..

Choose the most important materials or tools and brainstorm ways to make this happen.

..

..

..

..

..

..

..

..

"Remember where your light's coming from."

Bob would add just a little bit more white to a green, or a little more black to blue.

Similarly, it's important to keep lighting top of mind—and adjust it to make it perfect. Though proper lighting is important for any creative space (imagine not being able to see the red of your pasta sauce!), it's especially important in a room or area devoted to painting, photography, digital production, printing, sculpture, needlework, or other traditional visual and decorative arts for which you need to differentiate colors. Do you have enough natural light coming in? Is the overhead or spot lighting you're using have a yellow, white, or other cast that's altering the colors you see?

Also, think about the colors surrounding you. Are the colors of the walls or furniture affecting the colors you see in your artwork? If you're working in a space dedicated to your artwork, it might be best to have neutral colors surrounding you rather than bold or bright ones that may alter the way you or others perceive your art.

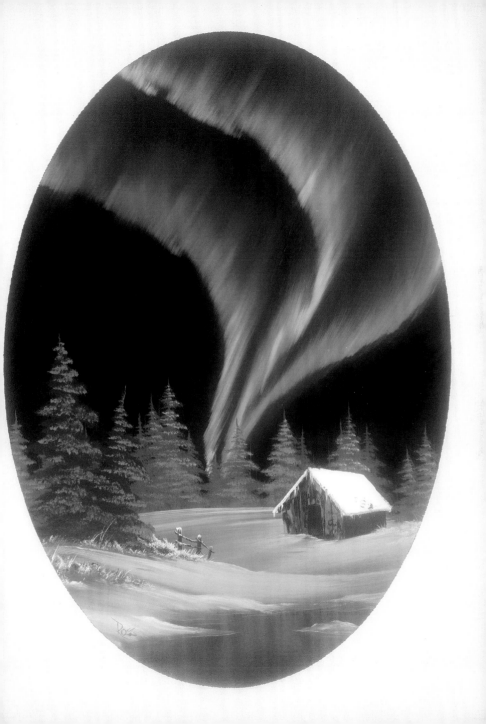

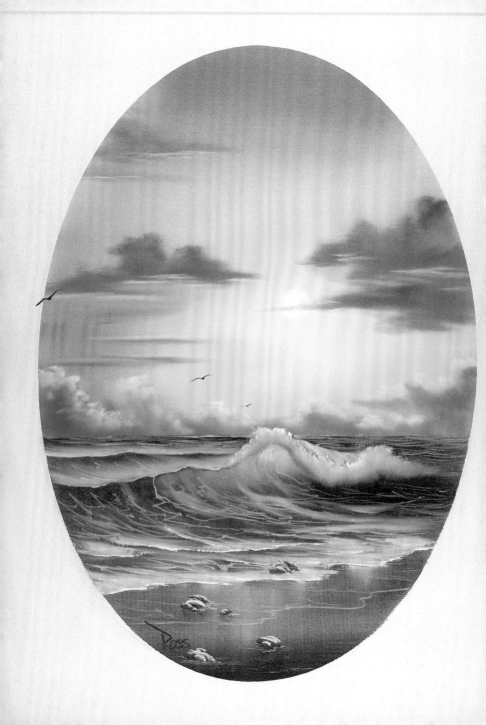

"If I paint something, I don't want to have to explain what it is."

Bob and his students were rightfully proud of the art they created.

You should be too! So whether you're cooking, painting, quilting, or making music, think of ways to display and highlight your art! Everyone knows we "eat with our eyes before our mouths," so think about your "plates" and "serving platters." If you're a musician or songwriter, consider framing some of your sheet music or even a treasured instrument on the wall. Think about display cases or lighting to make sure everyone who comes into your home can see—and admire—your ceramics. You writers could have dedicated shelves for the books you've written. And, of course, you visual artists might hang your works in areas where guests can appreciate them.

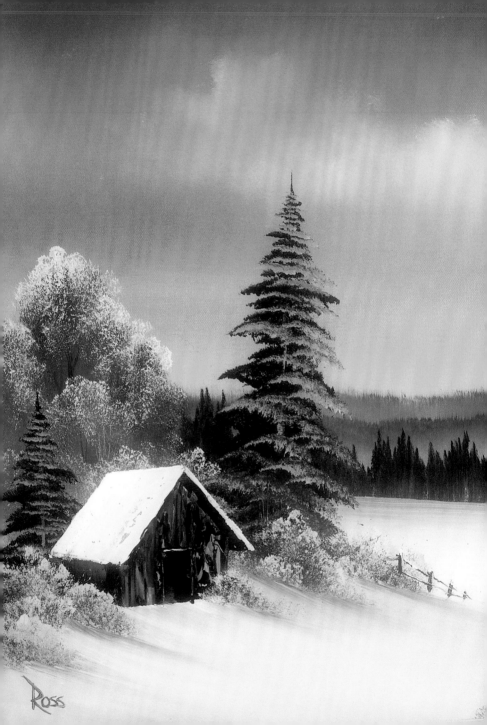

Work

"I'd like to take a few moments and thank all of the fantastic people here at the station that have worked so hard to make this show possible. They put in a great deal of time, they work very hard, and I think they produce a quality product."

As much fun as Bob looked to be having on air, it took as much work as joy to create eleven years of *The Joy of Painting*. Everyone behind the scenes had the physical space in the studio and offices to do their best work. Because most of us spend at least eight hours a day working, we need to do what we can to make the time as pleasant and comfortable as possible. Whether you're working from home, an office, in a retail establishment, or even in a vehicle, you can make your space more enjoyable and livable.

"This is not something you should labor over or worry about."

Bob could hold and feel the canvases he worked on,

as well as the sticky paints that might splatter or drip from his brushes. Even people who work digitally need physical, work-related tools, like samples, company handbooks, staplers, notebooks, and phone holders. The shift toward working from home is making many rethink setting boundaries between professional and personal lives, and the way personal spaces are annexed for professional needs. But while more and more businesses are transitioning to "paperless" models, you're probably still going to need things in your work-from-home space to get your job done.

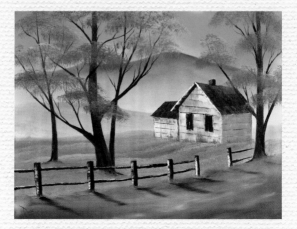

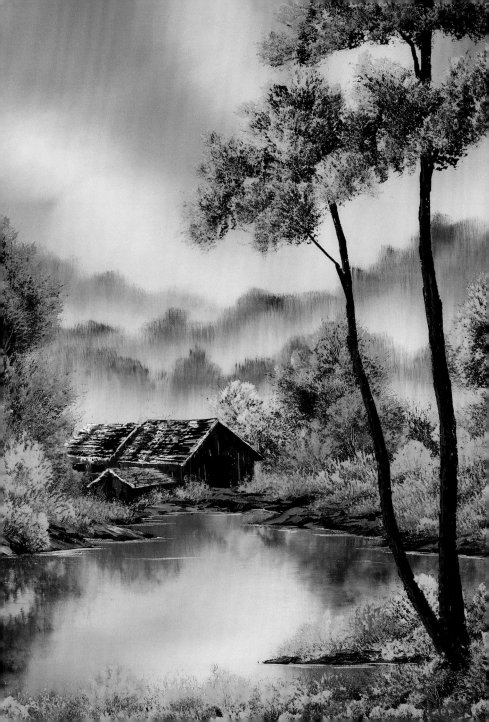

BRAVERY TEST

"Let's talk a minute about the equipment that we'll be using here."

Use this space to list the furniture, materials, equipment, files, or tools you need to do your job. Note which ones need to be out and at the ready and which can be stored for use.

..

..

..

..

..

Use this space to list ways those materials are currently organized and stored.

..

..

..

..

..

..

Note which ones need to be better organized and stored. Choose the most important materials and brainstorm ways to make this happen.

..

..

..

..

..

..

Use the space below to list the ideal amount of space you need to do your job, and the locations or areas that can accommodate your needs.

..

..

..

..

..

..

..

..

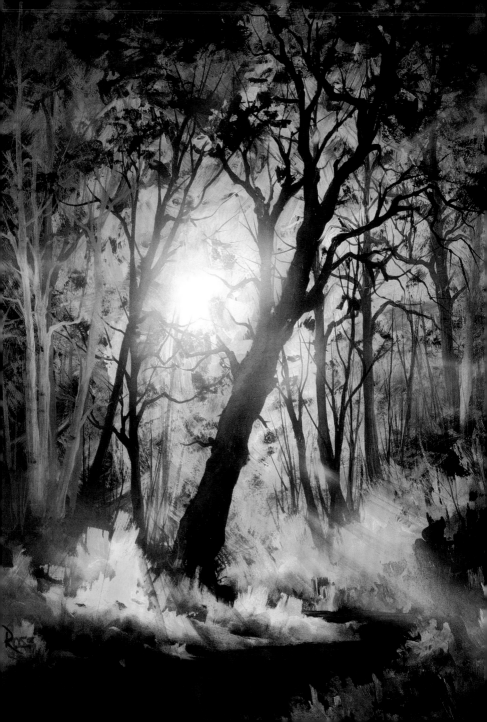

"We use a large palette that has a large working area on it."

Bob kept his colors separate on his palette and blended them with his brush.

Likewise, people who work from home need to take a look at how their workspaces function in their living spaces. Some of us have a dedicated room, basement, or garage that was intended to be (or has been repurposed as) a home office, while many of us live in tight or limited spaces. Think about how working in a particular space is going to affect your productivity and how your work life may affect that space. For example, it's pretty easy for dining room tables and kitchen islands to be cleared or living room tray tables to be pushed aside in the evenings. But seeing your computer on the table beside your bed might bring unwanted stress from your workday into the moments you most want to relax.

Though Bob's friend Peapod the squirrel worked at finding and hiding his nuts in the great outdoors, he couldn't have been productive had there not been sunlight streaming through the trees to guide him toward the ripe nuts. The colors and lighting of your home workspace can affect your productivity as much as it does your creativity. Make sure your workspace offers you enough natural light and fresh air to stay awake.

"This will excite people!"

Bob had the good fortune to be able to work in a studio,

which was not only set up for standard television production but also able to be customized to make it look and feel like a personal working art studio. For those who work in offices, employers might offer the opportunity to personalize individual workspaces. Before you start changing anything, think about the size and layout of your workspace or desk, and how much of it you can devote to personalizing it without impeding your productivity. Use magnets or non-permanent strips to hang up photos or postcards of your favorite things. One of the simplest and most common ways to decorate a cubicle or office is by hanging up a calendar featuring art from your favorite artist, television show or movie, or even photos of your family and friends. Calendars are both practical and decorative, and will signal your likes and interests to anyone coming by. If you do have extra desk or shelf space, think about displaying framed photos, small mementos, collectibles, or even stress

relievers! And if you're lucky enough to have a space with access to a window, think about a potted plant. Flowers can provide a lovely pop of color (but be mindful of any allergies your coworkers might have)!

And if you don't work in an office, there may be ways for you to add a little Bob Ross into your work life. If you have a locker, think about decorating the inside with art, postcards, or photographs. These will not only bring a smile to your face but give you the chance to showcase a bit of your personality. Or consider the common spaces you share with your work friends. Among seasonal holidays, there might be opportunities for you and your coworkers to decorate hallways, break rooms, kitchens, or meeting rooms with artwork or elements that you've purchased or created yourselves.

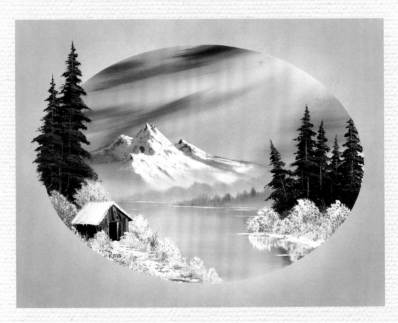

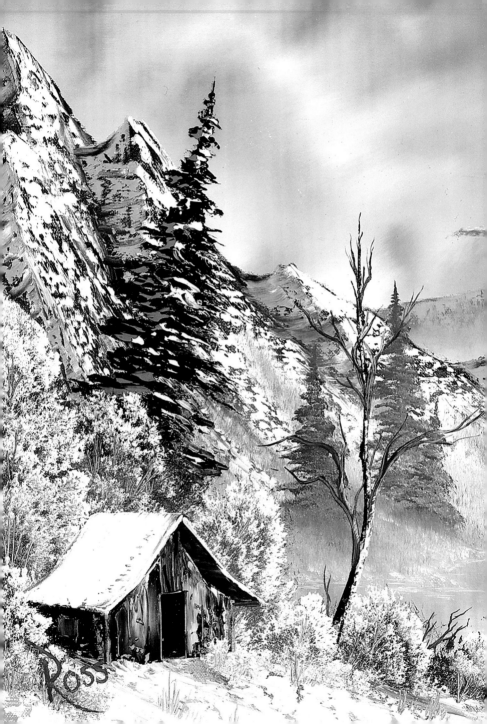

BRAVERY TEST

"What the heck, enjoy it!"

Use this page to list your personal workspaces (even if they are common areas), and ways they could be personalized or decorated to bring joy into your work life.

...

...

...

...

...

...

...

...

...

...

...

...

...

...

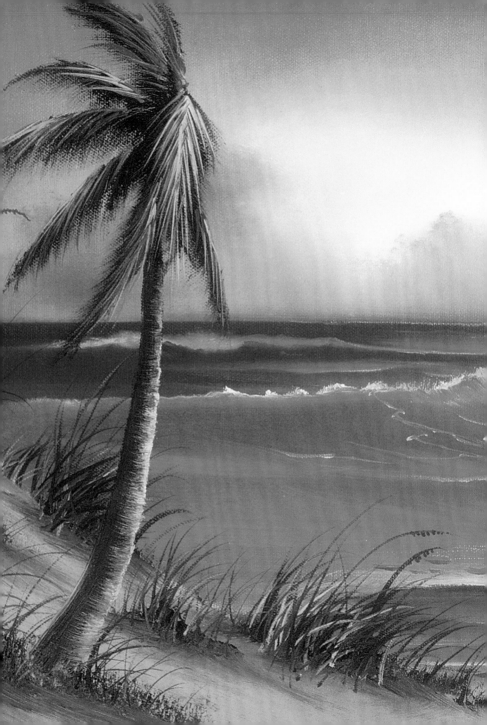

Rest and Self-Care

"Just let go."

Before "unplugging" was used in the common vernacular, Bob was a lifelong proponent of doing whatever you could to de-stress, recharge, and nurture the creative spirit. Bob's soothing voice, slow pace, and calm demeanor gave (and continues to give) viewers the opportunity to take a break from their hectic days and enjoy at least twenty-six minutes of peace and quiet. Bob understood that everyone deserved time to collect themselves. Your home could be a safe and personal space for you to retreat, rest, and recharge.

Even if your home is filled with the most joyous kind of chaos, your bedroom should be considered your ultimate space for refuge from the world. And like every other room in your home, the feel of your bedroom can be amplified by the colors you choose. From the wall colors to those of your sheets, the colors in your bedroom should evoke a sense of calm.

BRAVERY TEST

Use this page to list the colors and color combinations that are currently in your bedroom. Then list the colors you associate with restfulness and comfort. Are there any new colors or color combinations you should include in your bedroom now? List them here.

..

..

..

..

..

..

..

..

..

..

..

..

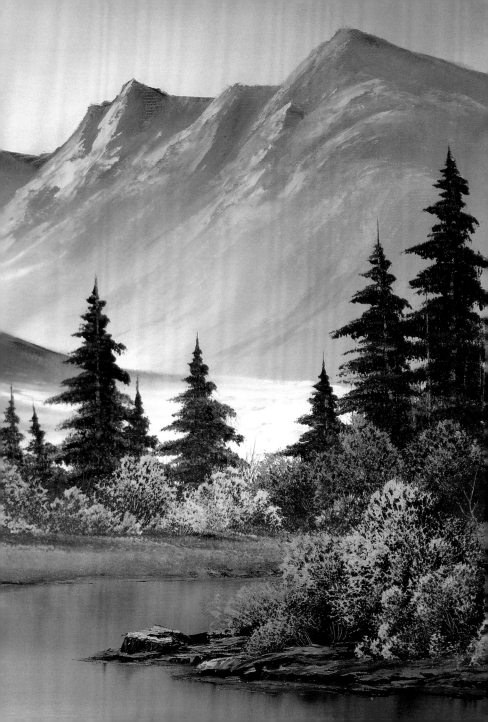

"See how it fades right into nothing. That's just what you're looking for."

As beautiful as Bob's paintings of dense and overgrown forests are,

for some people they may evoke a more claustrophobic feeling than those featuring wide-open, airy spaces. The layout of your bedroom, and the amount of stuff you have in it can affect the level of comfort you feel. A small room with a large bed, a medium-sized room with too much furniture, or even a large room filled with piles of laundry, unused exercise equipment, and racks of clothing can feel as unsettled as any child's playroom—and antithetical to the concept of rest.

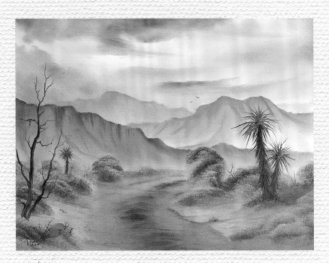

BRAVERY TEST

Use this page to sketch the current layout of your bedroom and list the things that can be removed, put away, or better organized:

Many of Bob's paintings featured three specific elements that can be associated with relaxation:

water, air, and wood. When used alone or together in a bedroom, they can create a particularly calming space.

Many people head to the beach or riverside to enjoy warm weather. Even for those who prefer spending time in a pool or a bath, or sitting beside a fountain, the sounds of running water, the weightless act of floating in it, and the experience of having the stress (and grime) of the day wash away are as restorative as a good night's sleep. Few of us have a waterbed these days, but you can enjoy some of the best attributes of water by considering the fabrics and textiles you're practically floating in all night. Thanks to modern textile innovations, you don't have to spend a lot of money, but because your bare skin is coming into direct contact with them, it may be worth it to invest in good-quality sleeping clothes and sheets.

"Water's like me. It's lazy."

"Just let these big old clouds float around in the sky and have fun. Clouds are about the freest thing in nature."

We've all heard the expression of "walking on air."

And how many of us want to sleep on air and rest our heads on one of Bob's happy little clouds? You may prefer soft clouds, or have other preferences regarding the firmness of pillows and mattresses, so take advantage of the huge variety of offerings and find the one (or the combination) that works best for you. Things might get complicated if you're sharing a bed, but these days lots of mattresses are being manufactured to accommodate two different sleepers at once.

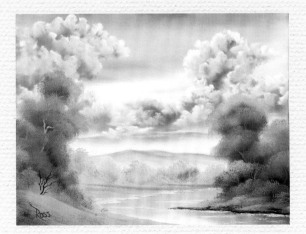

"Sometimes we make evergreens by pushing down, sometimes by pushing upward."

So many of Bob's landscapes feature strong, sturdy trees.

Representations of the physical strength of wood, they are also meta-phors of the tether that exists between water in the earth and water in the air. By supporting the ecosystem in large and small ways, trees are a key element in keeping nature's balance. So think about the fur-niture in your bedroom in this way, including your bedframe, head-board, dresser, bedside table, and storage. Are they uniform like a row of evergreens . . . or are they an eclectic mix of trees, bushes, and shrubs? Very importantly, do you like it that way? Do they provide you with as much storage as Peapod would need to hide his acorns (or at least enough storage for your things)? Do they support your mattress enough or does your bedframe need to be higher, lower, or sturdier? Is your flooring comfortable the moment you set your feet upon it?

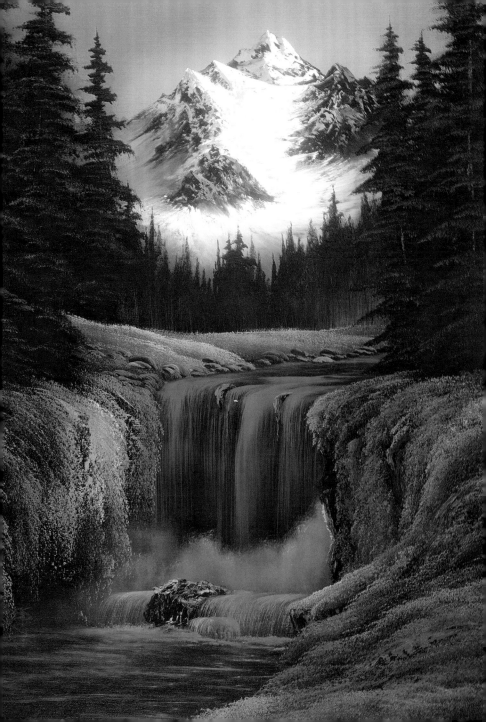

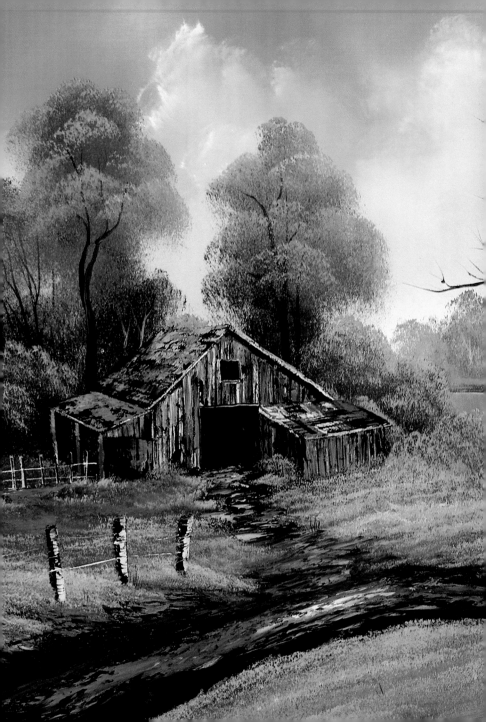

Nature

*"Spend some time with nature.
Let it become your good friend."*

Nobody was better at bringing nature into people's homes than Bob Ross. Over the course of his career, he created thousands of landscapes and encouraged millions to create billions of landscapes of their own. Each of these works of art allowed anyone to re-create and interpret the wonders and majesty of nature in their own homes.

From houseplants lining windowsills to collections of shells set upon bathroom sink counters to bowls of plastic fruit placed on coffee tables, bringing *the outdoors in* has been a thing since people moved in from outdoors!

BRAVERY TEST

Use this space to list or draw some natural colors and elements to which you feel a personal or emotional connection.

"Let's just go right in here and begin
dropping in some happy little trees and bushes,
and let's see them flow off your brush."

Bob could spend hours making friends with trees.

But aside from the ones displayed at Christmas, few trees ever make it into anyone's home. Houseplants, flowers, terrariums, and herbs are some of the easiest ways to bring nature inside. They add fragrance, beauty and bounty (in the case of herbs or vegetable plants), and they also clean the air. Remember that most require light to thrive. So, pick a place or places—whether on a windowsill or in a planter or flowerpot—where they can get enough sunlight or artificial light throughout the day. You'll also have to water and feed them, too! If remembering to water a plant is too much, instead consider crystals, rocks, or shells. Though not everyone believes they also clean the air or provide metaphysical benefits, everyone can agree that they provide a lovely, organic mix of colors and textures.

Bob would often remark on the sounds of nature as well as its sights. Think about ways to bring the sounds of nature into your home. It may be as easy as opening a window to hear birds sing, or adding small fountains so you can enjoy hearing running water, or even an ambient noise machine that can offer you a wide variety of sounds ranging from a babbling brook to a thunderstorm.

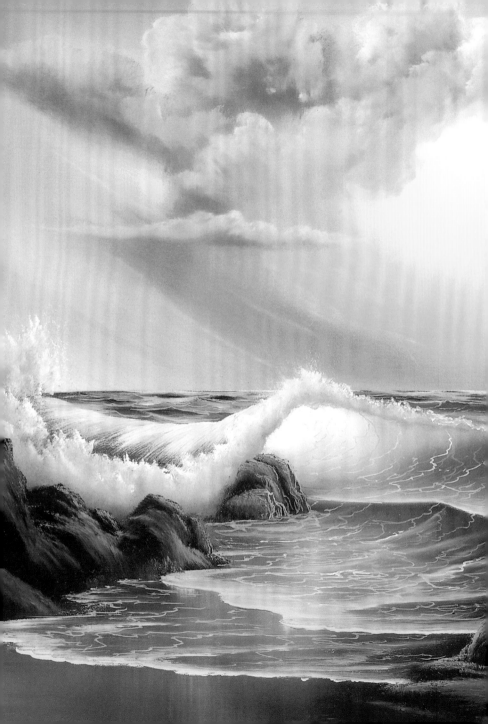

"You know, one of the hardest things in the world is to figure out when to stop."

Bob Ross passed away in 1995. But his creative spirit continues to inspire us to use our imagination and creative spirit to create—and share—a world that is beautiful, cooperative, and peaceful.

"So, I think with that, we'll close this one. I want to wish you the absolute every possible joy that life can bring."

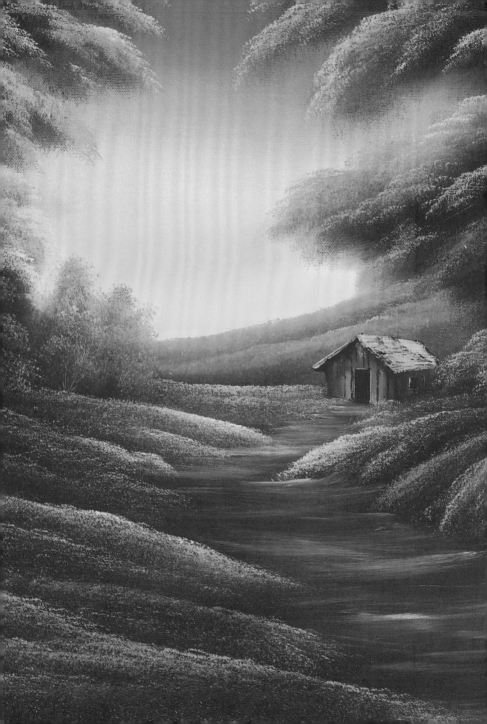

Thanks & Acknowledgments

Thanks to everyone at Rizzoli Universe, especially Charles Miers, Jessica Fuller, Lynn Scrabis, Colin Hough Trapp, and Elizabeth Smith for their trust and support. Sincere thanks to designer Lynne Yeamans, and, as always, to Joan Kowalski for allowing me to play a part in Bob Ross's legacy.

No amount of thanks could be enough to David Rosen, for making this book possible, and for making our house a home.

First published in the United States of America in 2023 by
Universe Publishing, A Division of Rizzoli International Publications, Inc.
300 Park Avenue South
New York, NY 10010
www.rizzoliusa.com

®Bob Ross name and images are registered trademarks of Bob Ross Inc.
All Rights Reserved. Used with permission.

Bob Ross and squirrel image © Advanced Graphics, Inc.
Used with permission.

Brushstrokes: Brushstroke ©shutterstock/Azuzl

Publisher: Charles Miers
Editor: Elizabeth Smith
Design: Lync
Production Editor: Colin Hough Trapp
Managing Editor: Lynn Scrabis

All rights reserved. No part of this publication may be reproduced,
stored in a retrieval system, or transmitted in any form or by any means,
electronic, mechanical, photocopying, recording, or otherwise,
without prior consent of the publishers.

Printed in China

2023 2024 2025 2026 / 10 9 8 7 6 5 4 3 2 1

ISBN: 978-0-7893-4144-0
Library of Congress Control Number: 2022948535

Visit us online:
Facebook.com/RizzoliNewYork
Twitter: @Rizzoli_Books
Instagram.com/RizzoliBooks
Pinterest.com/RizzoliBooks
Youtube.com/user/RizzoliNY
Issuu.com/Rizzoli

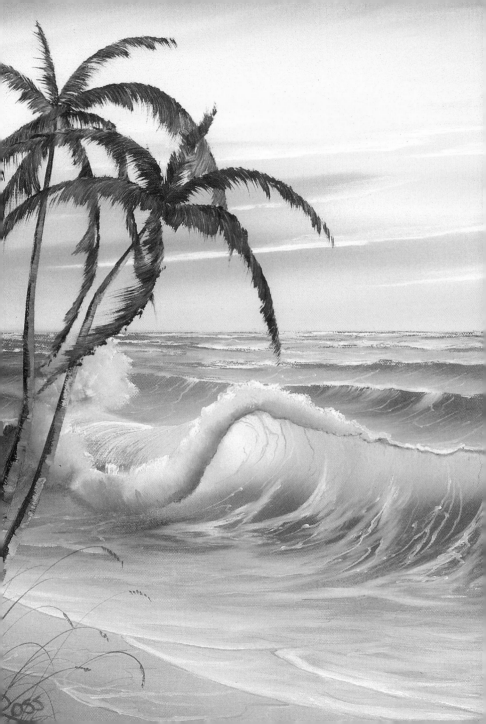

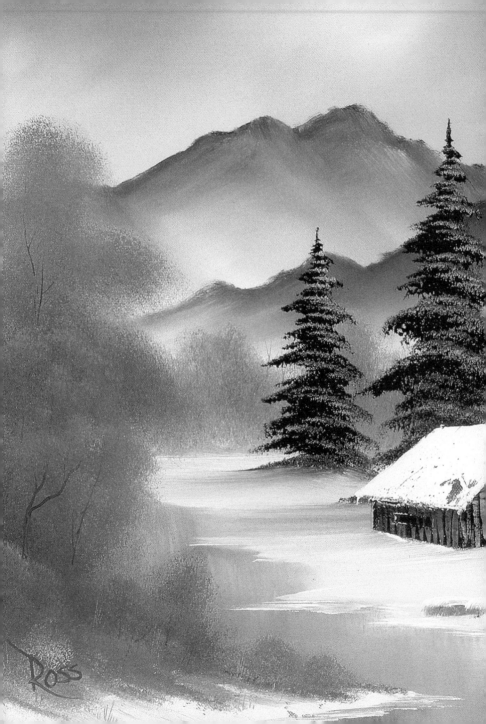